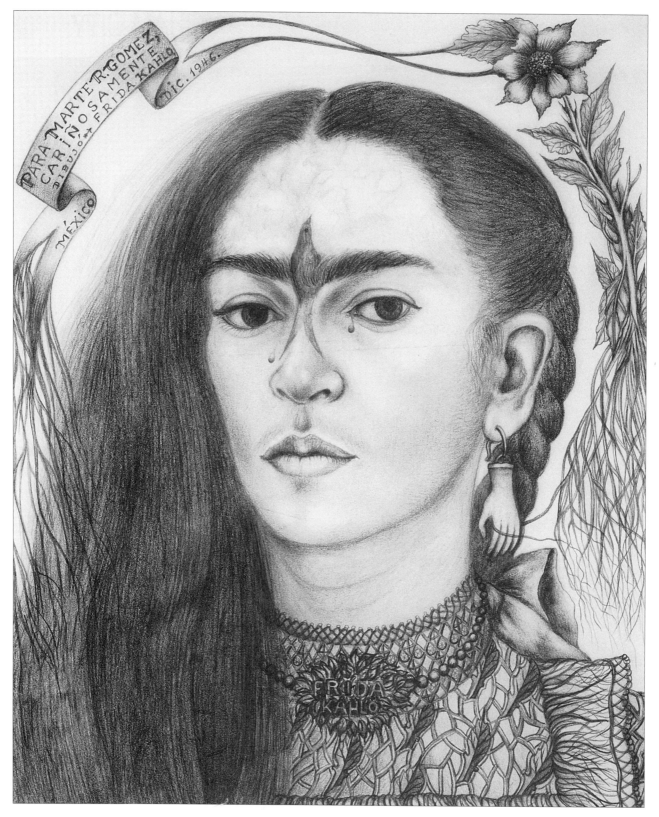

FRIDA KAHLO (1907-1954)
Self-portrait, 1946. Pencil on paper. 38.5 x 32.5 cm.

GREAT SELF-PORTRAITS

45 Works

EDITED BY
CAROL BELANGER GRAFTON

DOVER PUBLICATIONS, INC.
Mineola, New York

PUBLISHER'S NOTE

A SELF-PORTRAIT gives the viewer an intimate insight into the personality and life of an artist. The most memorable self-portraits are those that can represent both the feelings and emotions of the subject as well as his or her physical likeness. Self-portraits are rarely commissioned works, and thus possess an autonomy that renders them unique in an artist's oeuvre. Some artists, such as Dürer and Rembrandt, employed their own self-image as a tool for personal observation. A candid self-view of an artist's innermost feelings and character, self-portraits are also definitive public statements of an artist's professional life. The art of self-portraiture mainly focuses on how an artist wants to be perceived by others. For example, certain works clearly portray the artist's occupation by the inclusion of easels, brushes, and palettes, while others indicate status and success through fashionable clothing and physical expression. Each work of art in this collection of 45 drawings, etchings, and engravings conveys information about the artist through line, tone, shape, symbolism, and the consequent relationships among all of these.

Copyright

Copyright © 2002 by Dover Publications, Inc.
All rights reserved under Pan American and International Copyright Conventions.

Published in the United Kingdom by David & Charles, Brunel House, Forde Close, Newton Abbot, Devon TQ12 4PU.

Bibliographical Note

Great Self-Portraits: 45 Works is a new work, first published by Dover Publications, Inc., in 2002.

Library of Congress Cataloging-in-Publication Data

Great self-portraits: 45 works / edited by Carol Belanger Grafton.
　　p. cm. — (Dover art library)
　　ISBN 0-486-42168-6 (pbk.)
　　1. Self-portraits. I. Grafton, Carol Belanger. II. Series.

　　N7618 .G74 2002
　　760'.0442—dc21

2002067462

Manufactured in the United States of America
Dover Publications, Inc., 31 East 2nd Street, Mineola, N.Y. 11501

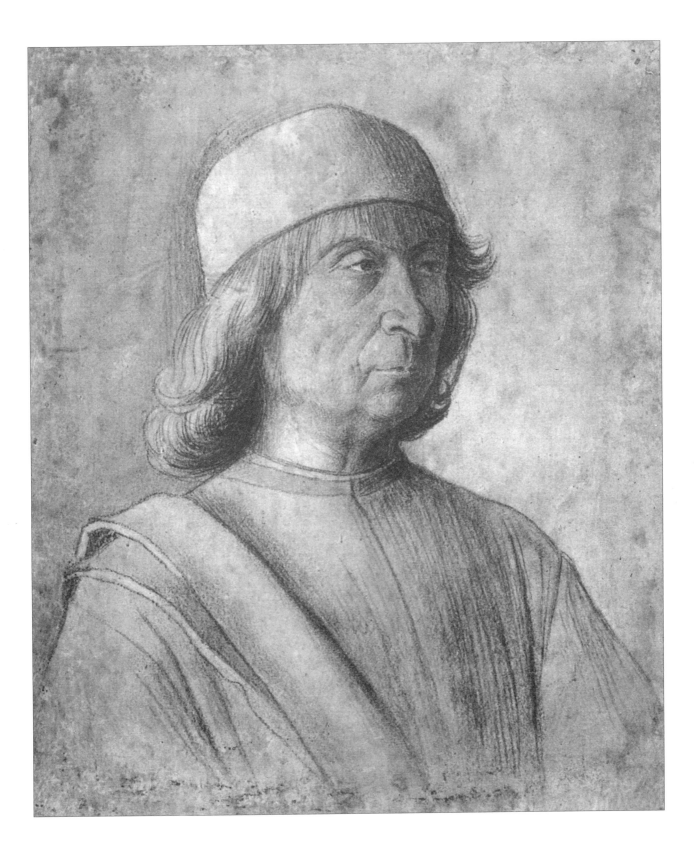

1 / GENTILE BELLINI (1429–1507)
Self-portrait, 1480. Silverpoint on paper. 23 x 19.5 cm.

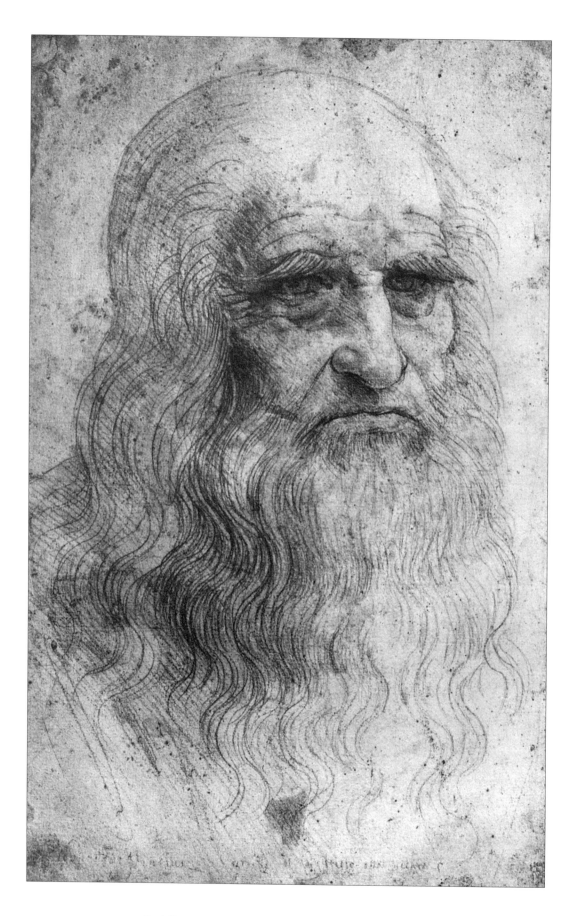

2 / LEONARDO DA VINCI (1452-1519)
Self-portrait, 1510. Red chalk on paper. 33.3 x 21.4 cm.

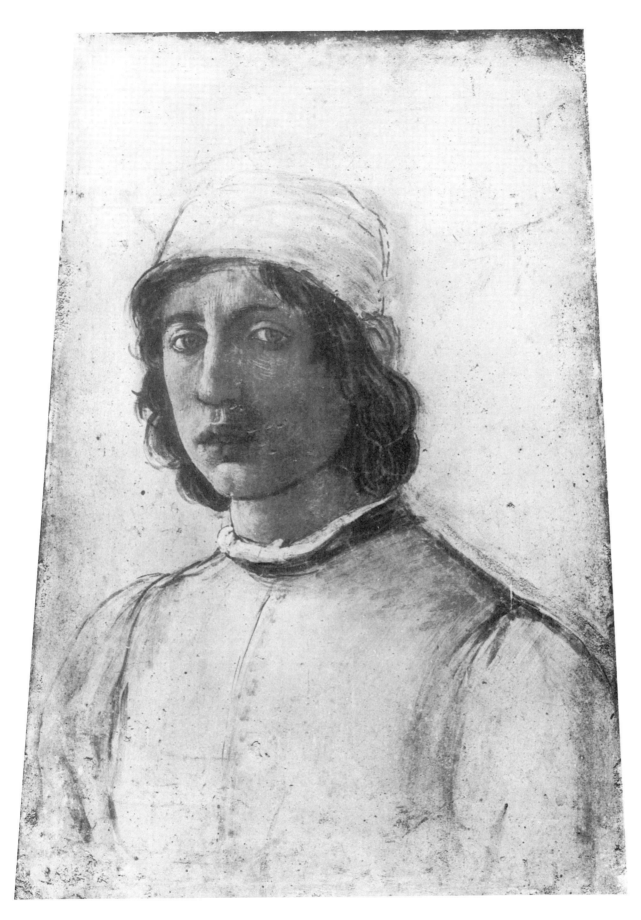

3 / FILIPPINO LIPPI (1457-1504)
Self-portrait, 1485. Tempera on roof tile. 50 x 31 cm.

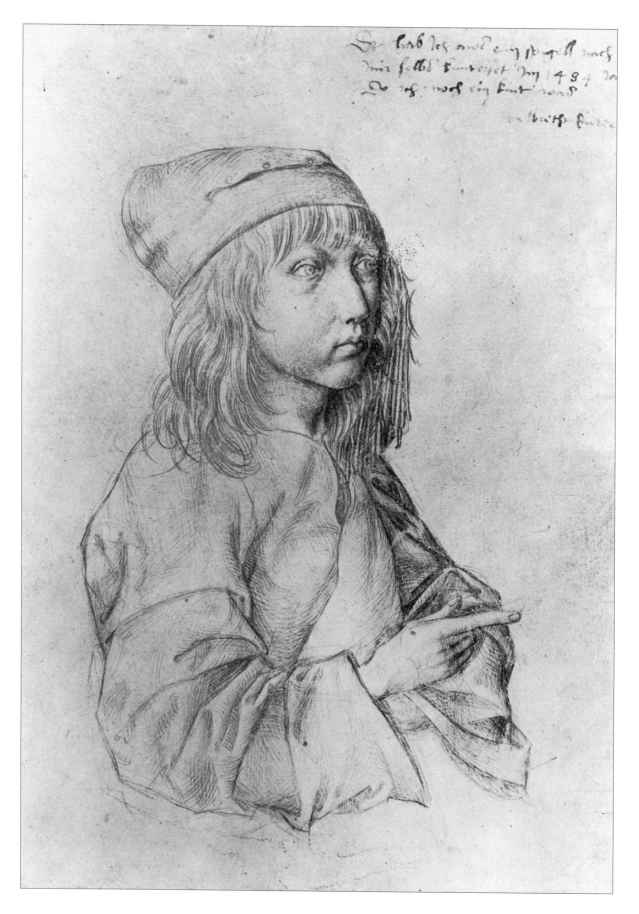

4 / ALBRECHT DÜRER (1471–1528)
Self-portrait, 1484. Silverpoint. 27.5 x 19.6 cm.

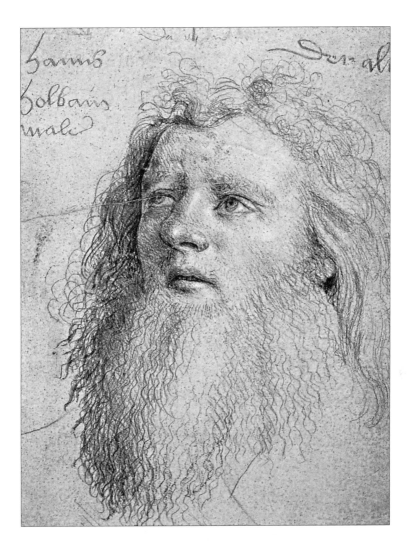

5 / HANS HOLBEIN THE ELDER (1465-1524)
Self-portrait, 1517. Silverpoint and red chalk on paper. 13 x 10 cm.

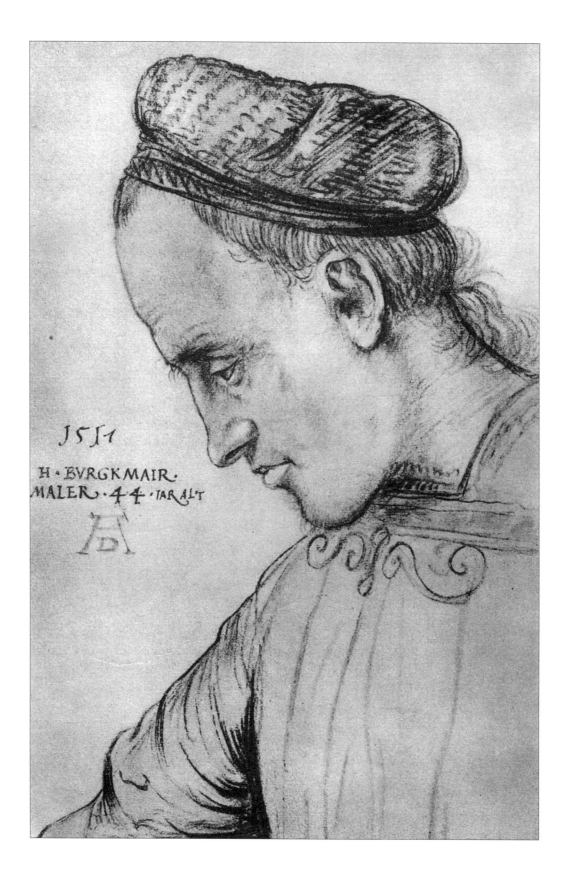

6 / HANS BURKMAIR (1473-1531)
Self-portrait, 1517.

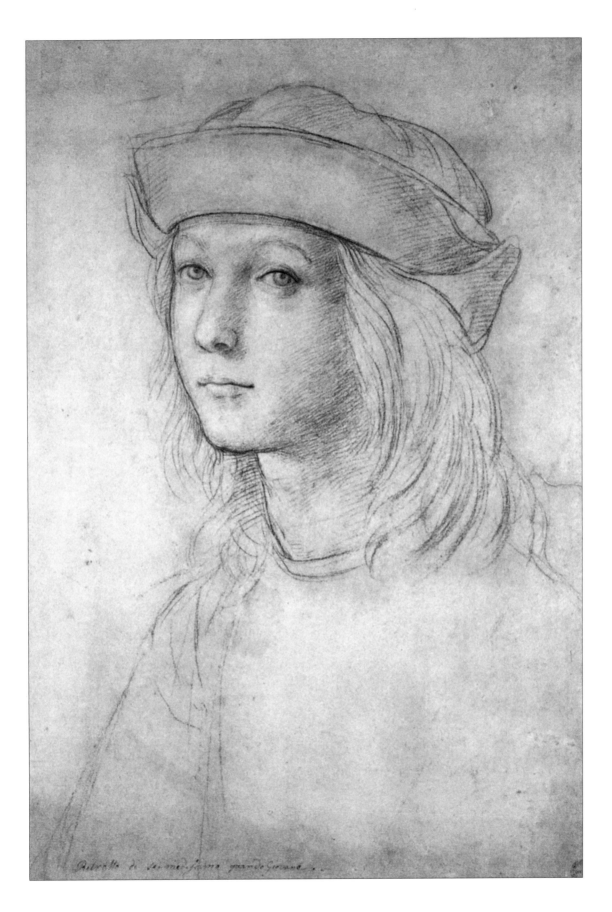

7 / RAPHAEL (1483-1520)
Self-portrait, 1504. Black chalk on paper. 38 x 26 cm.

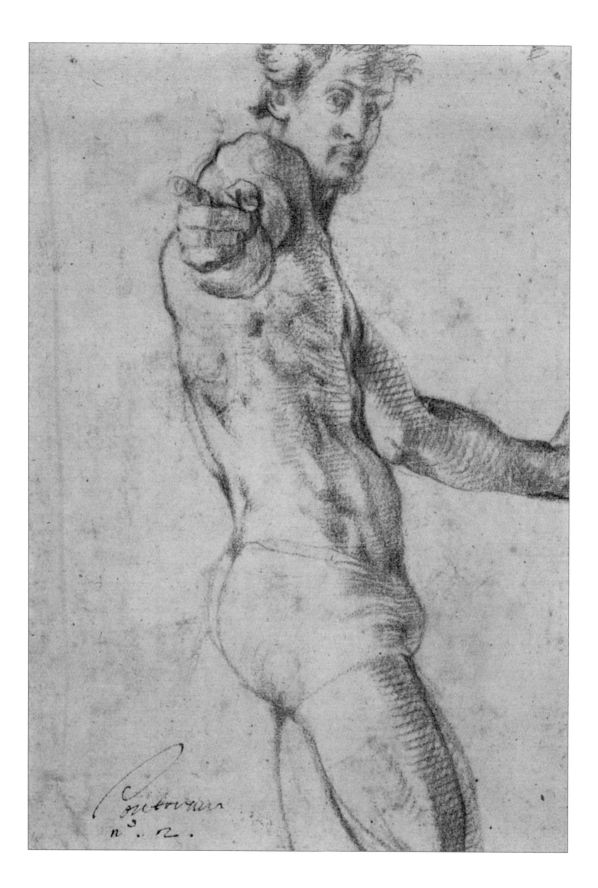

8 / Jacopo da Pontormo (1494-1557)
Self-portrait, 1525. Red chalk on paper. 28.4 x 20.2 cm.

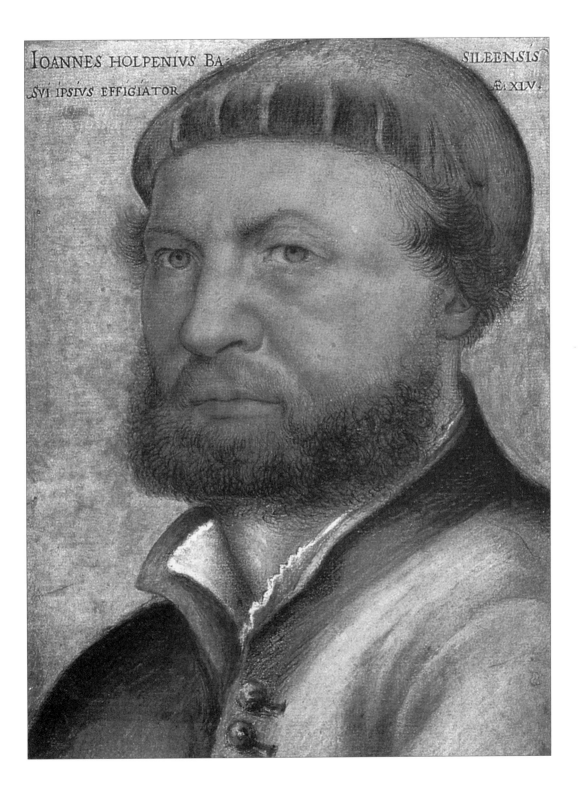

IOANNES HOLPENIVS BA[SILEENSIS]

SILEENSIS

SVI IPSIVS EFFIGIATOR

Æ XLV

9 / HANS HOLBEIN THE YOUNGER (1497–1543)
Self-portrait, 1542. Color pencil on paper. 32 x 26 cm.

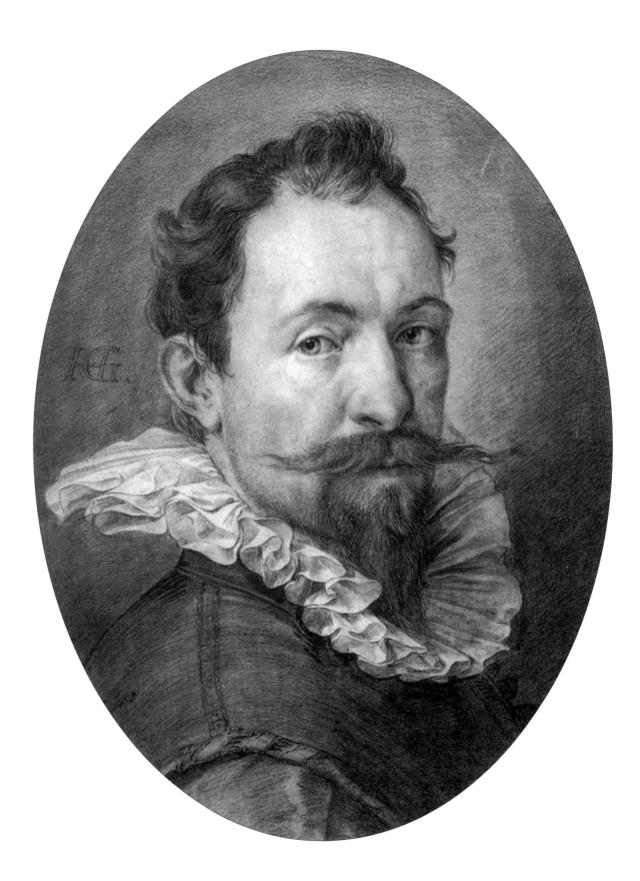

10 / Hendrick Goltzius (1558-1617)
Self-portrait, 1600. Black and red chalk and pen and ink on paper. 43 x 32.3 cm.

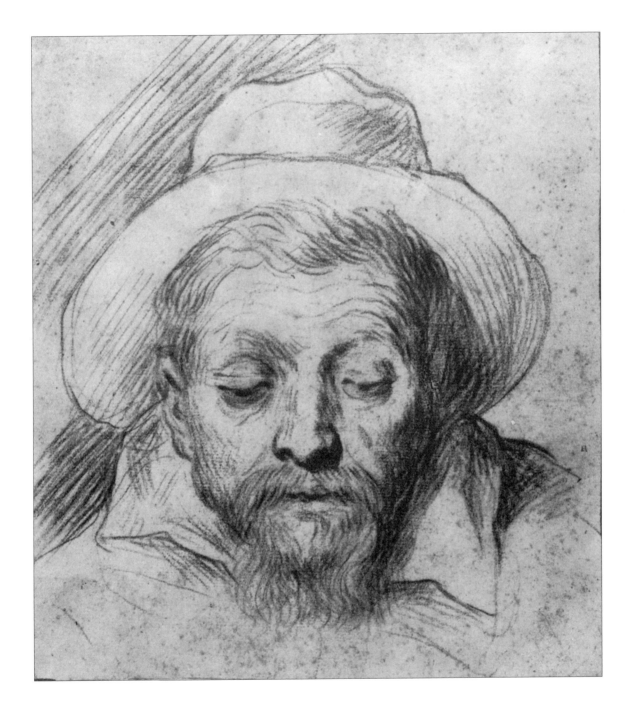

11 / PALMA GIOVANE (1544-1628)
Self-portrait, undated. Red chalk. 17.6 x 15.7 cm.

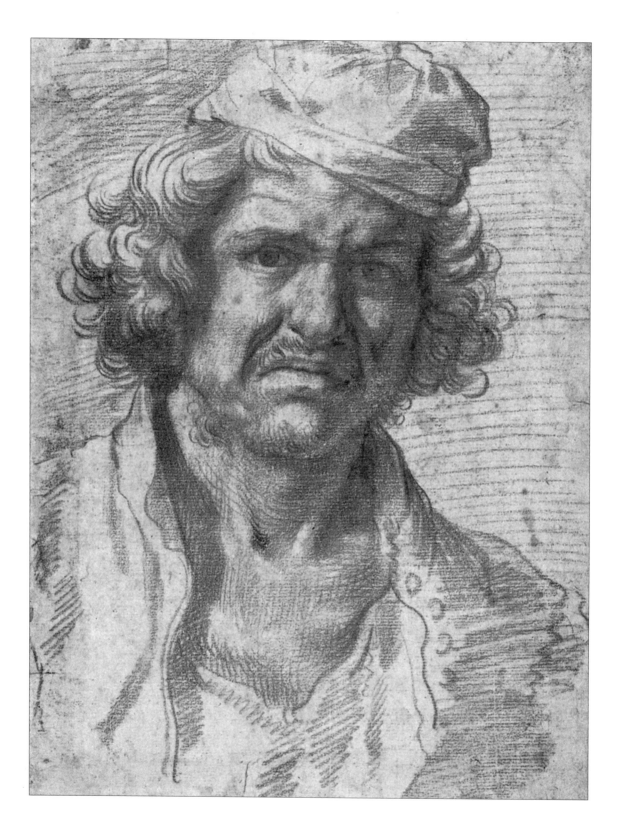

12 / Nicolas Poussin (1594-1665)
Self-portrait, 1630. Red chalk on paper. 37.5 x 25 cm.

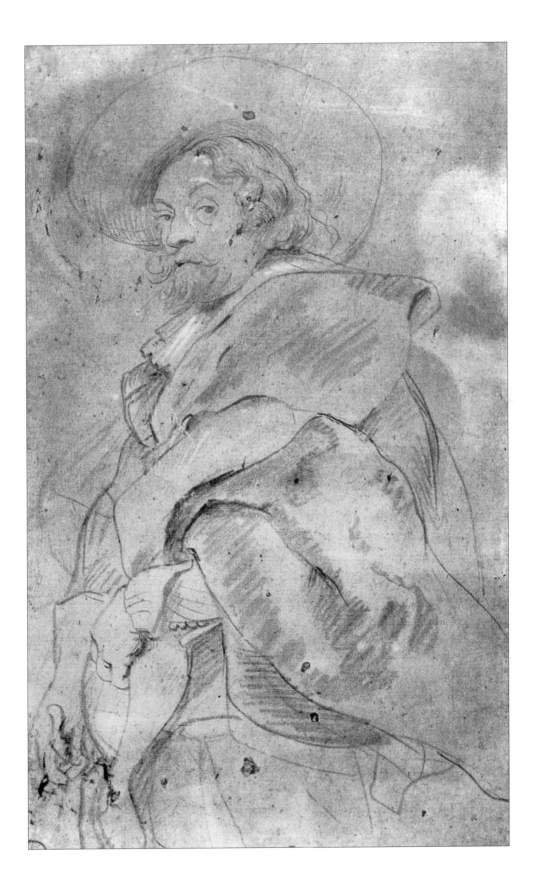

13 / Peter Paul Rubens (1577-1640)
Self-portrait, 1639. Chalk on paper.

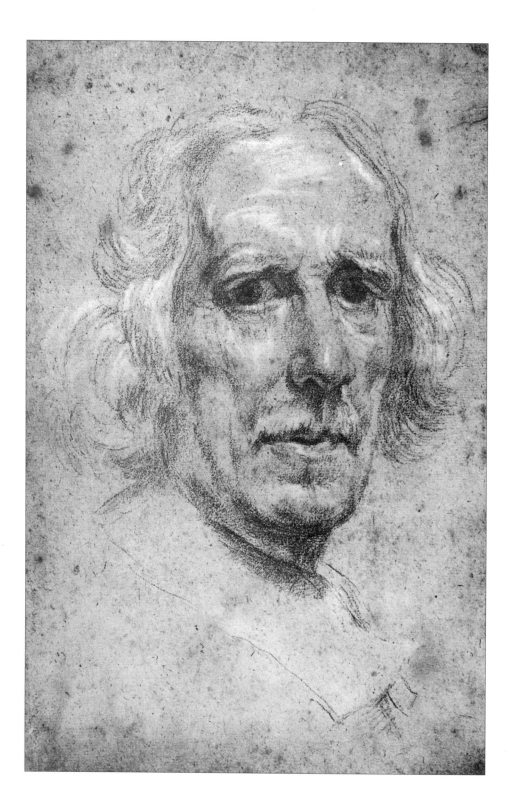

14 / GIANLORENZO BERNINI (1598-1680)
Self-portrait, 1665. Black chalk on gray paper. 41.3 x 27.1 cm.

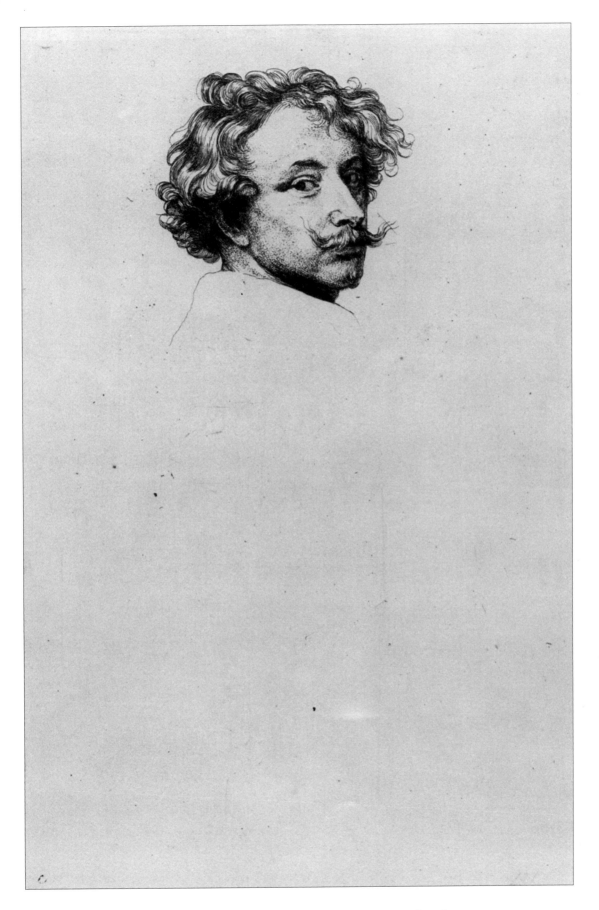

15 / Anthonie van Dyck (1599-1641)
Self-portrait, undated. Etching. 23.5 x 15.8 cm.

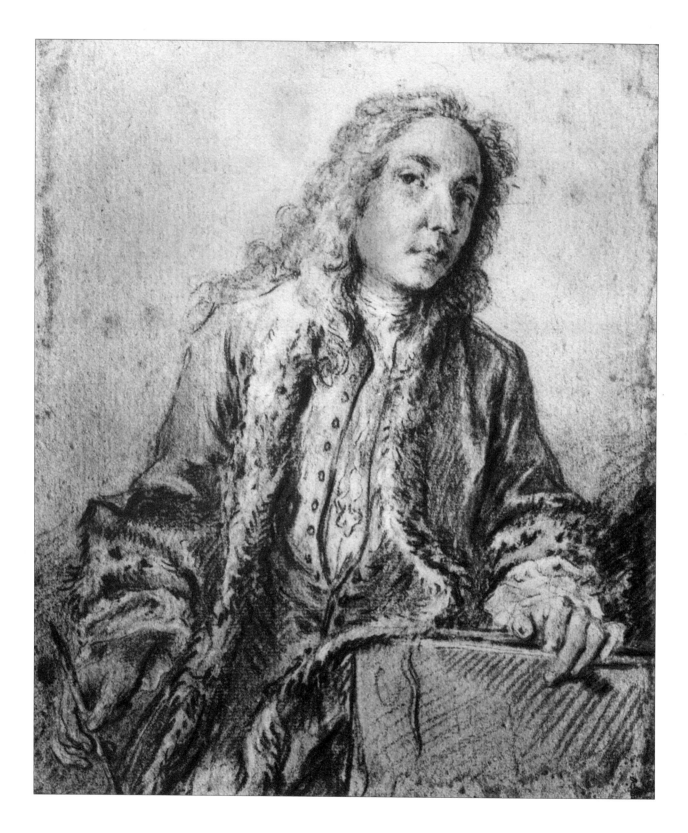

16 / ANTOINE WATTEAU (1684-1721)
Self-portrait, undated. Three colors of chalk on paper.

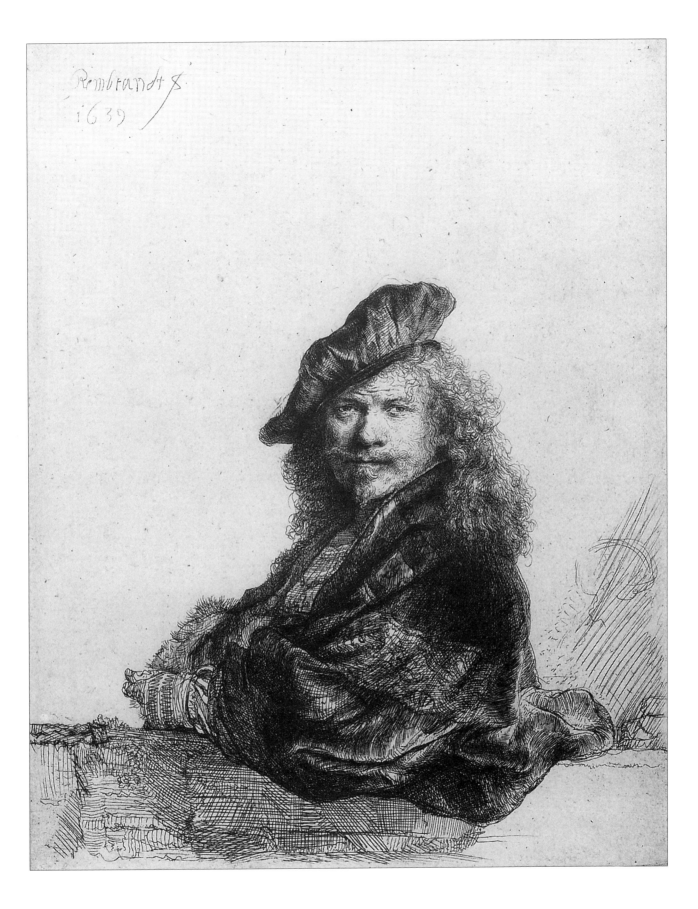

17 / Rembrandt van Rijn (1606-1669)
Self-portrait Leaning on a Stone Wall, 1639. Etching. 36.9 x 29.8 cm.

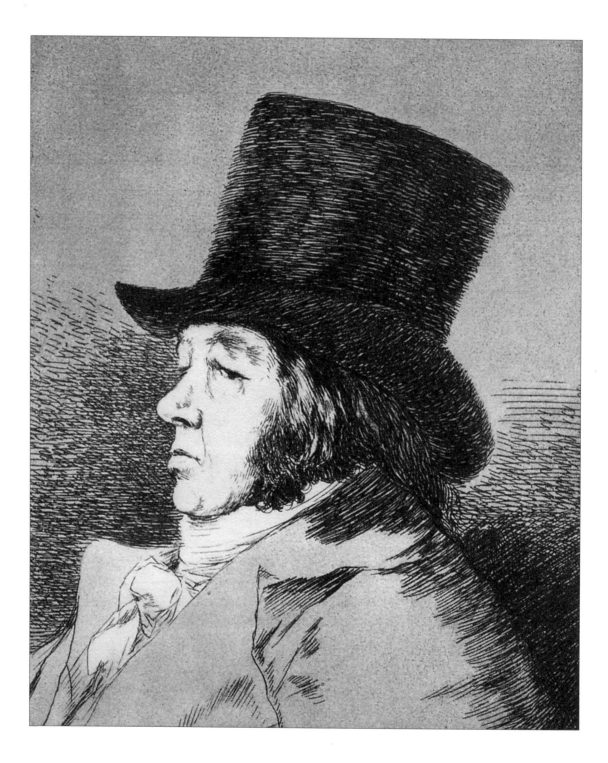

18 / Francisco Goya (1746-1828)
Self-portrait, 1798. Etching and aquatint. 21.9 x 15.2 cm.

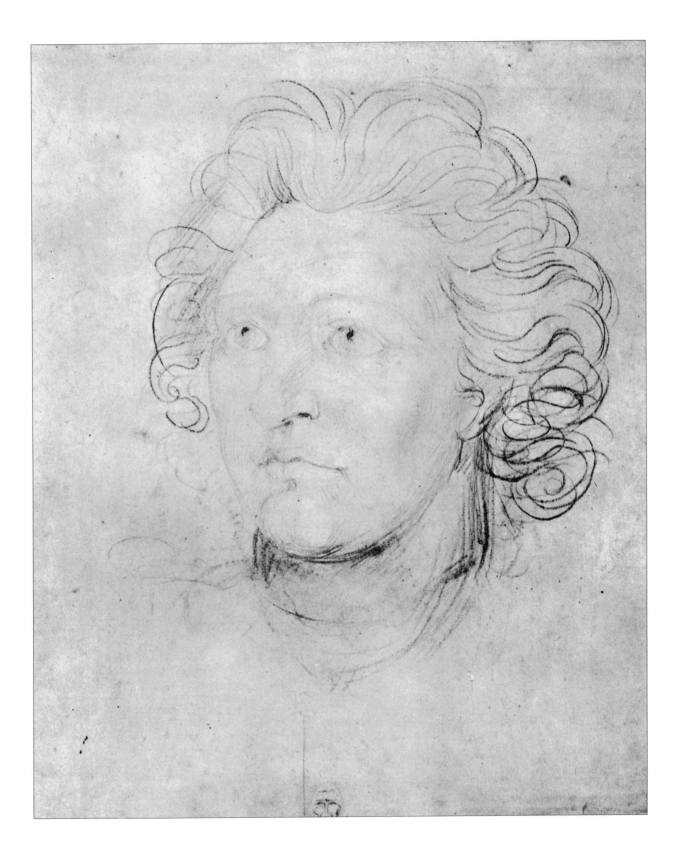

19 / William Blake (1757–1827)
Self-portrait, undated. Black chalk. 28.2 x 25.7 cm.

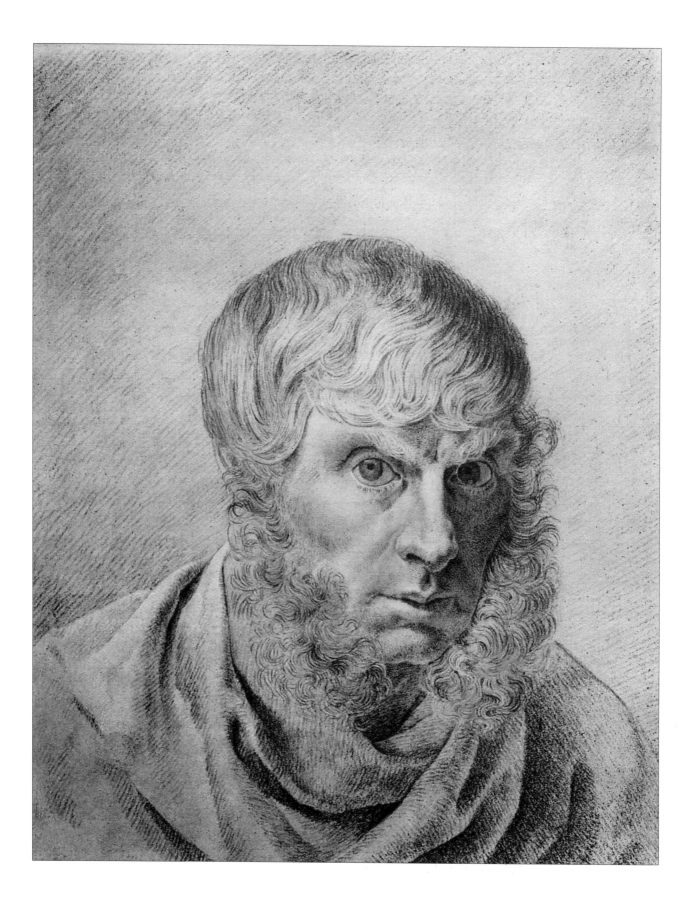

20 / CASPAR DAVID FRIEDRICH (1774-1840)
Self-portrait, 1810. Black chalk on paper. 22.9 x 18.2 cm.

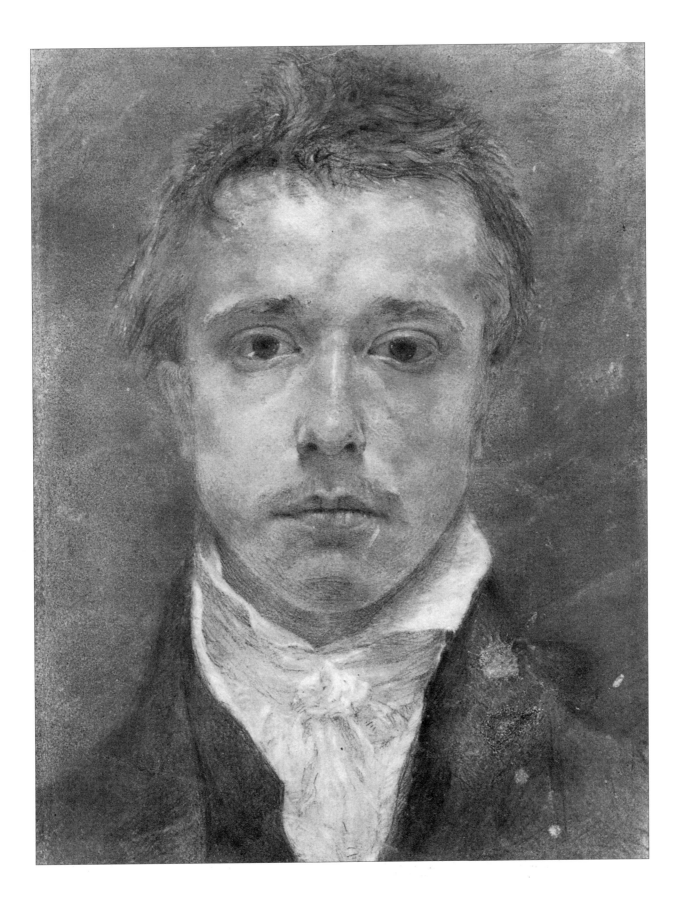

21 / SAMUEL PALMER (1805–1881)
Self-portrait, undated, c.1826. Black chalk heightened with white on buff paper. 29.2 x 22.8 cm.

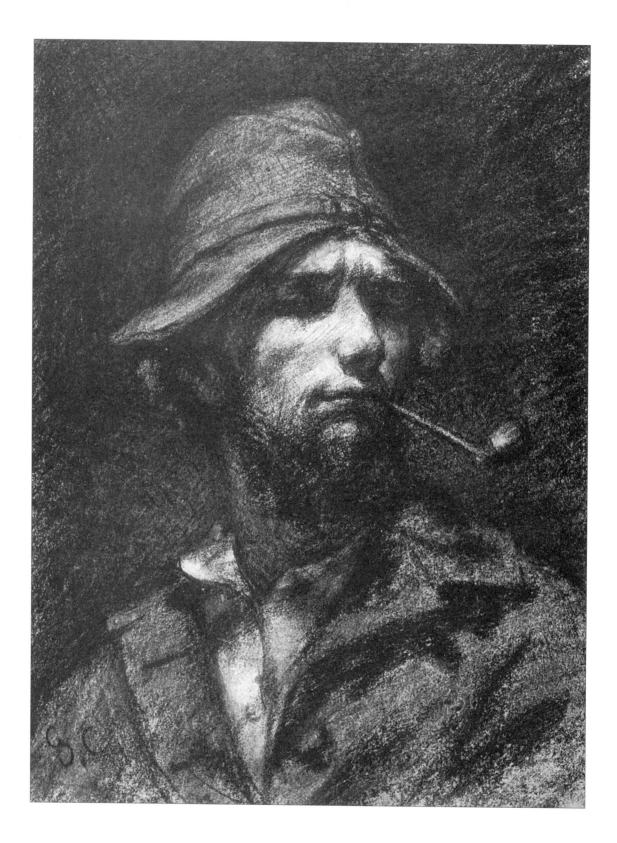

22 / GUSTAVE COURBET (1819-1877)
Self-portrait (The Man with a Pipe), c.1847. Charcoal on white paper. 27.7 x 20.3 cm.

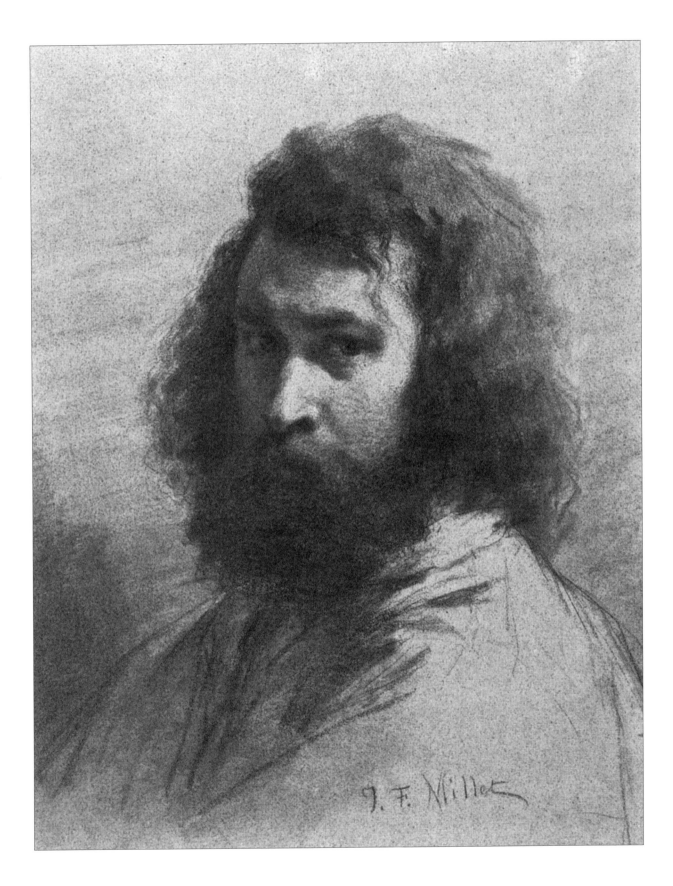

23 / Jean-François Millet (1814-1875)
Self-portrait, 1845-46. Pencil and black chalk on gray-blue paper. 56.2 x 45.6 cm.

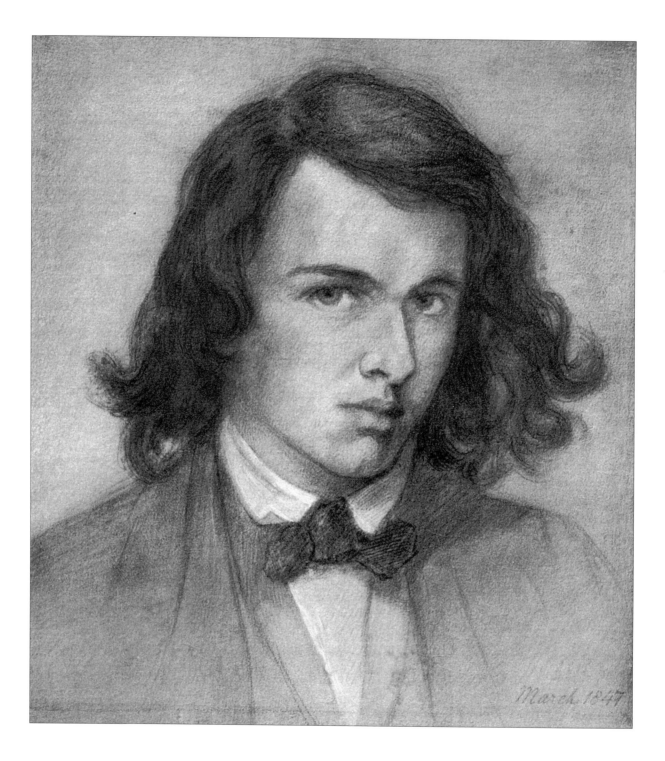

24 / Dante Gabriel Rossetti (1828-1882)
Self-portrait, 1847. Pencil heightened with white on paper. 19.7 x 17.8 cm.

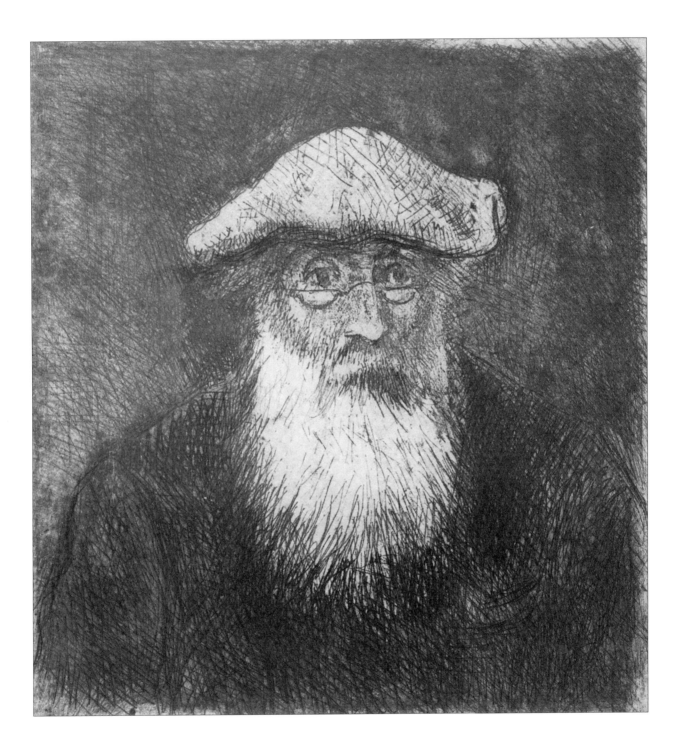

25 / Camille Pissarro (1830-1903)
Self-portrait, 1890. Etching. 18.5 x 17.9 cm.

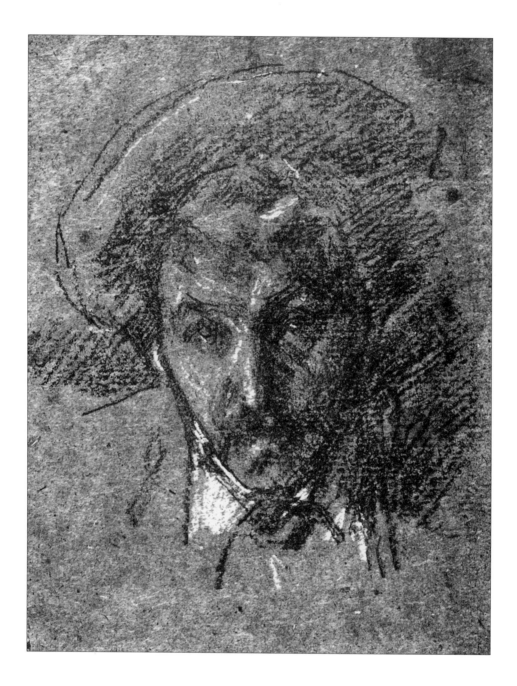

26 / James Abbott McNeill Whistler (1834–1903)
Portrait of the Artist, undated. Black and white chalk on brown paper. 16.8 x 12.7 cm.

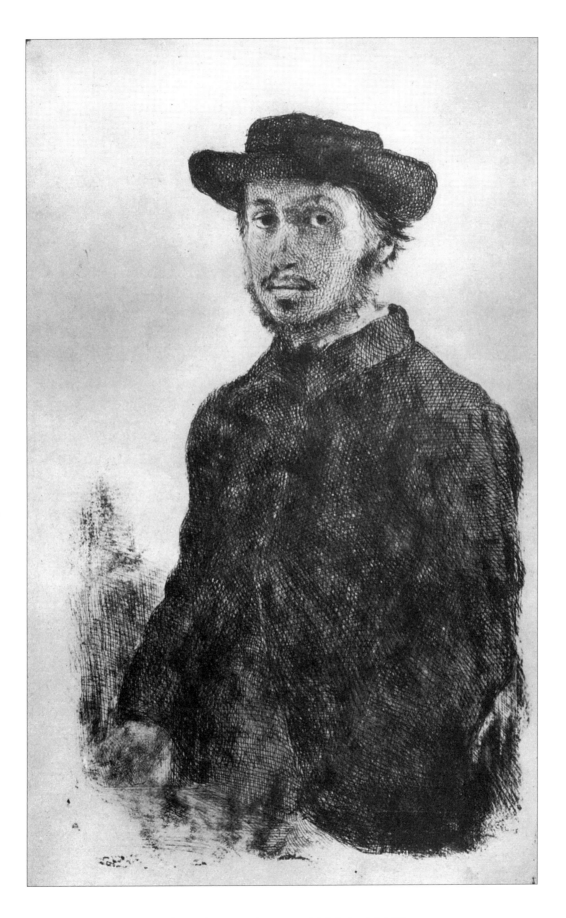

27 / Edgar Degas (1834-1917)
Self-portrait, 1857. Etching. 23.2 x 14 cm.

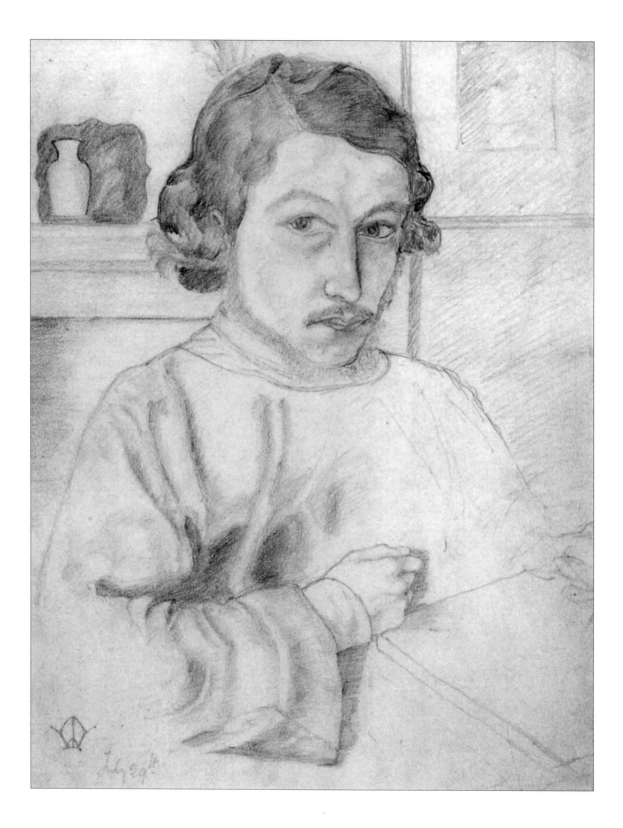

28 / WILLIAM MORRIS (1834-1896)
Self-portrait, 1856. Pencil. 28.5 x 22.1 cm.

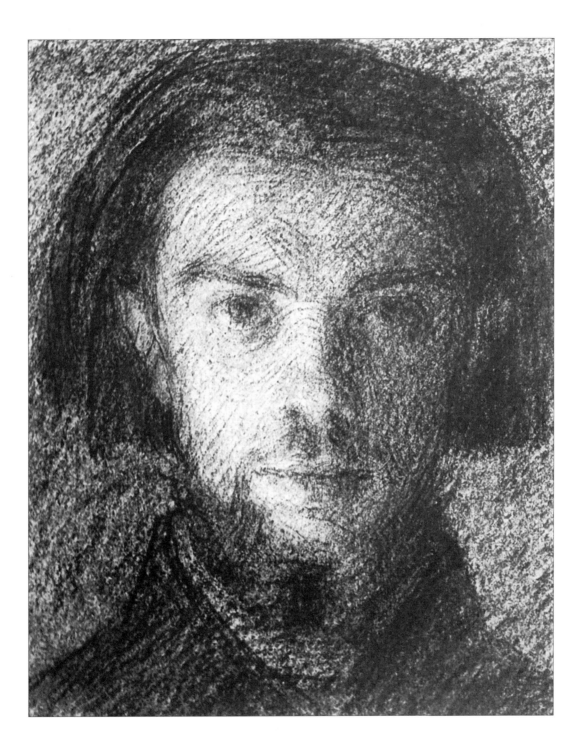

29 / HENRI FANTIN-LATOUR (1836-1904)
Self-portrait, undated, c.1860. Black chalk on off-white paper. 18.1 x 14.5 cm.

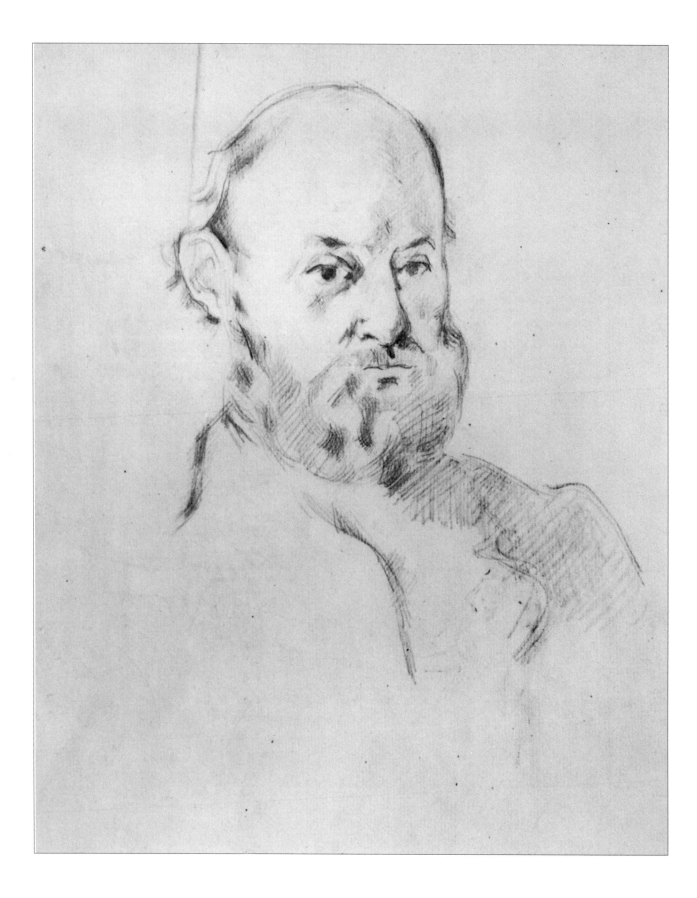

30 / Paul Cézanne (1839-1906)
Self-portrait, undated, c.1878-85. Pencil on off-white paper. 30.3 x 25 cm.

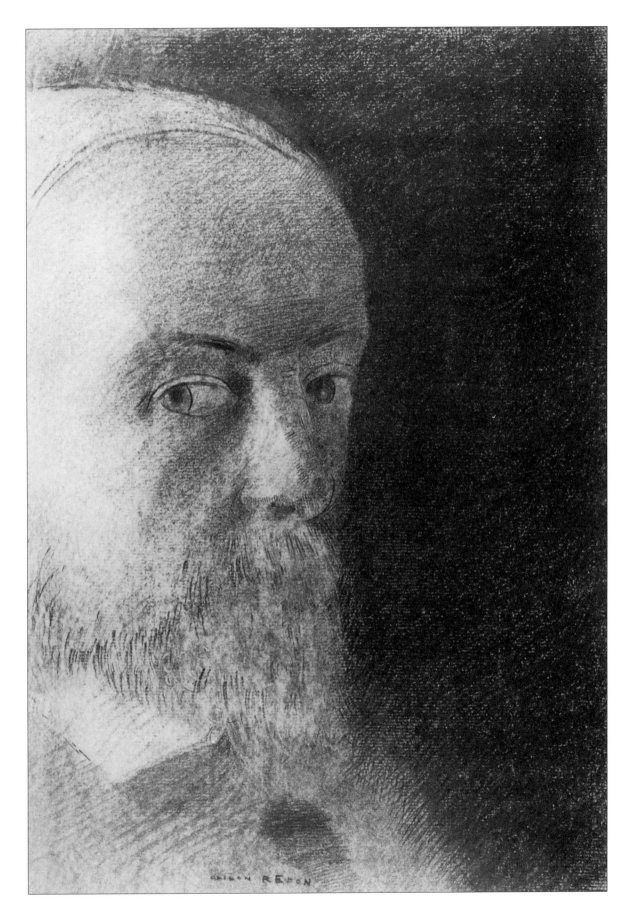

31 / ODILON REDON (1840-1916)
Self-portrait, 1888. Black chalk and charcoal on paper. 34.3 x 23.5 cm.

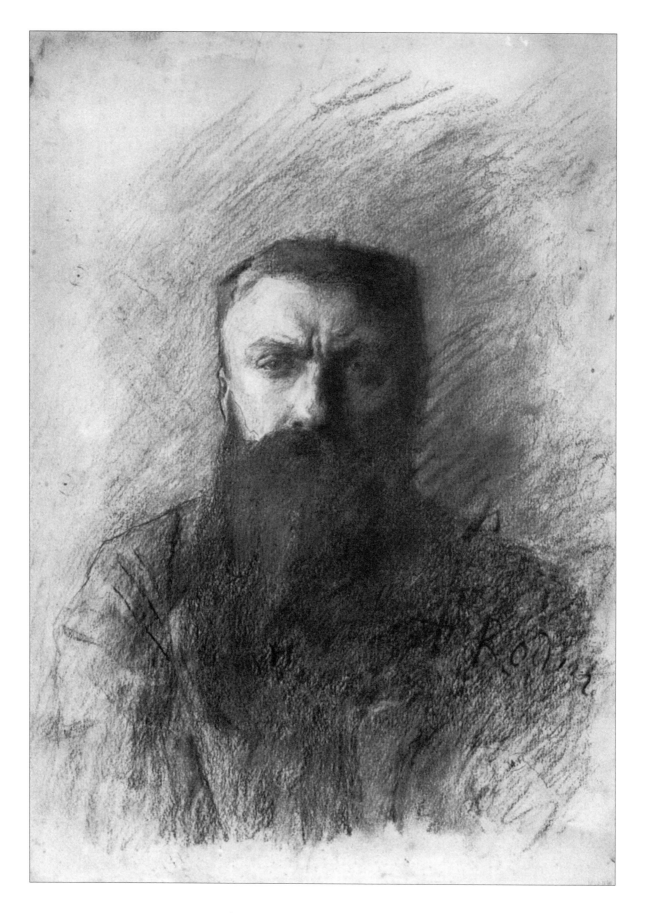

32 / Auguste Rodin (1840–1917)
Self-portrait, 1898. Charcoal on paper. 42 x 29.8 cm.

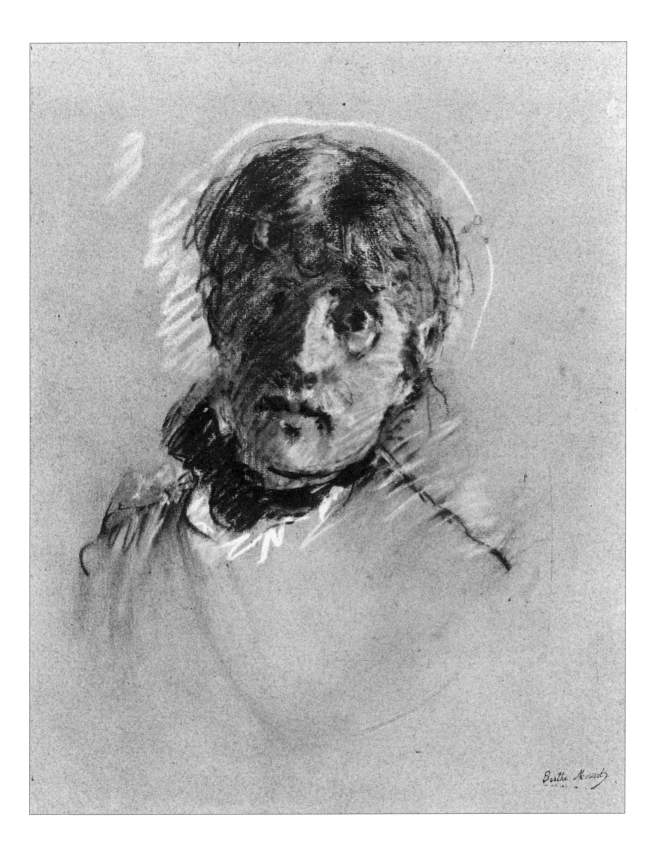

33 / BERTHE MORISOT (1841–1895)
Self-portrait, 1885. Pastel on gray paper. 46 x 36 cm.

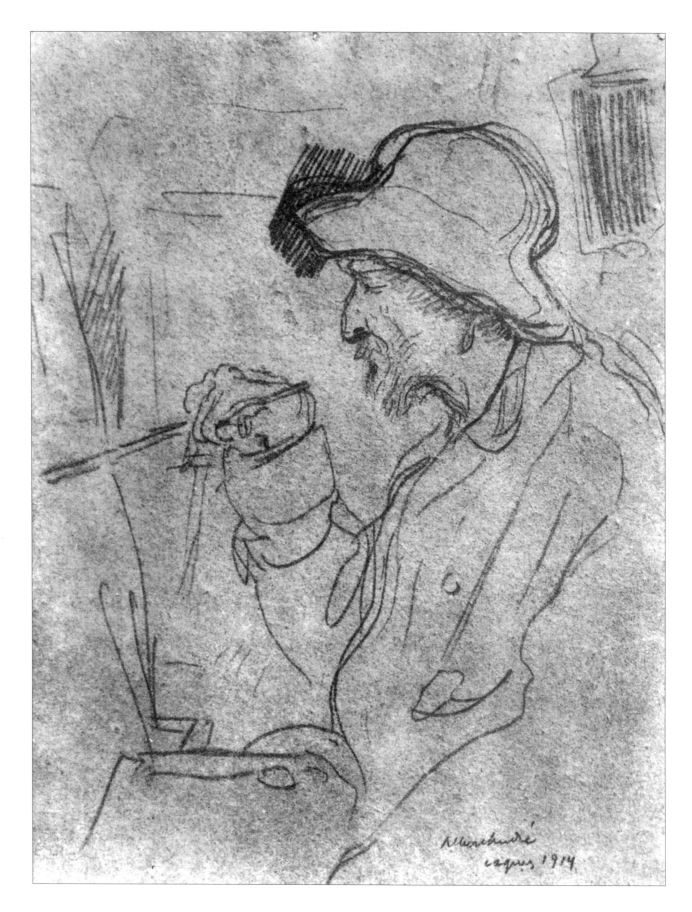

34 / PIERRE-AUGUSTE RENOIR (1841-1919)
Self-portrait, 1914. Pencil.

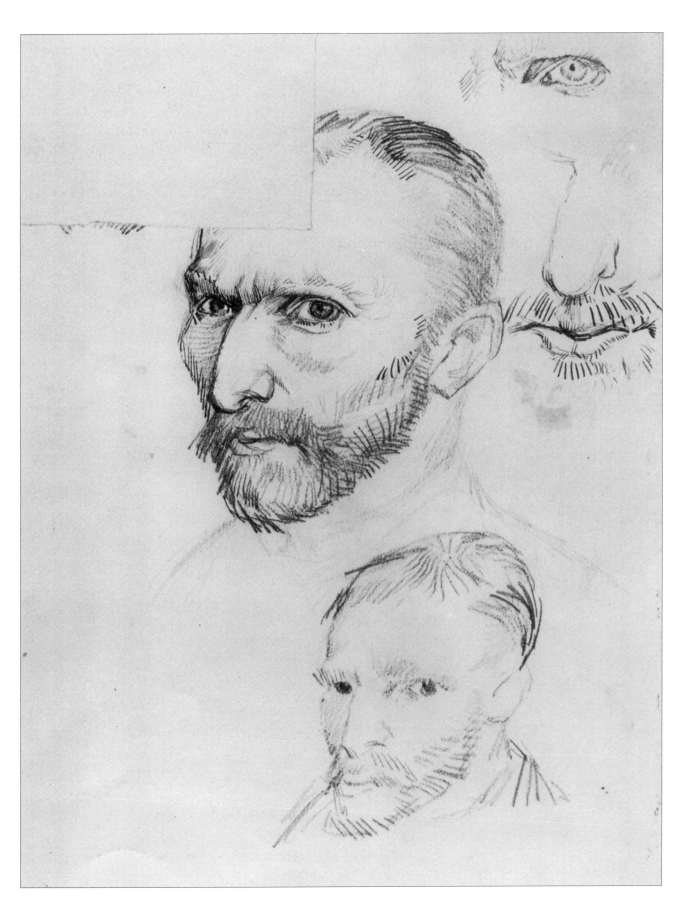

35 / VINCENT VAN GOGH (1853-1890)
Self-portraits, 1886. Pencil and ink. 31.5 x 24.5 cm.

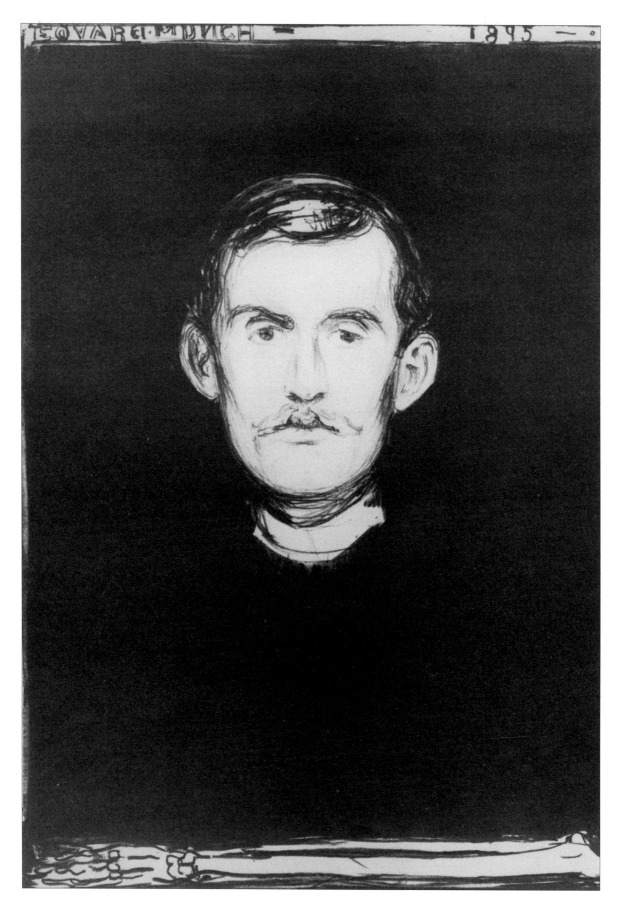

36 / Edvard Munch (1863-1944)
Self-portrait with Skeleton Arm, 1895. Lithograph. 45 x 31.5 cm.

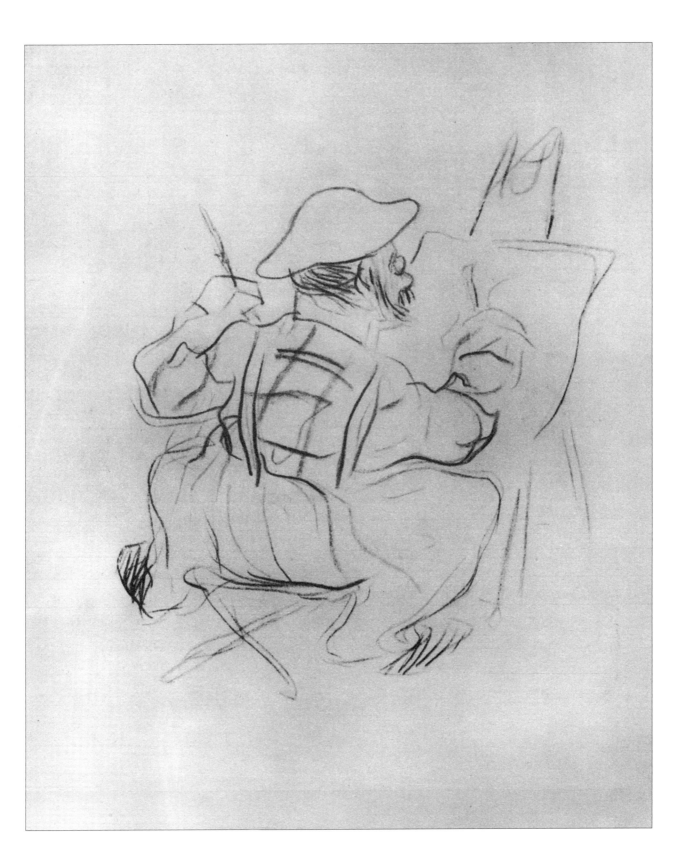

37 / Henri de Toulouse-Lautrec (1864-1901)
Self-portrait.

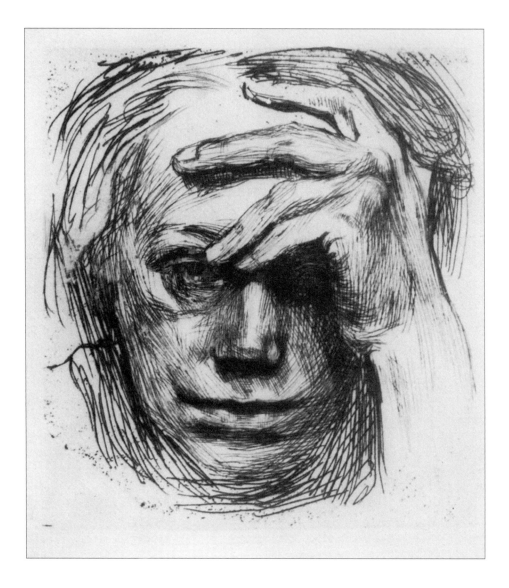

38 / KÄTHE KOLLWITZ (1867-1945)
Self-portrait with Hand on Her Forehead, 1910. Etching. 14.4 x 12.8 cm.

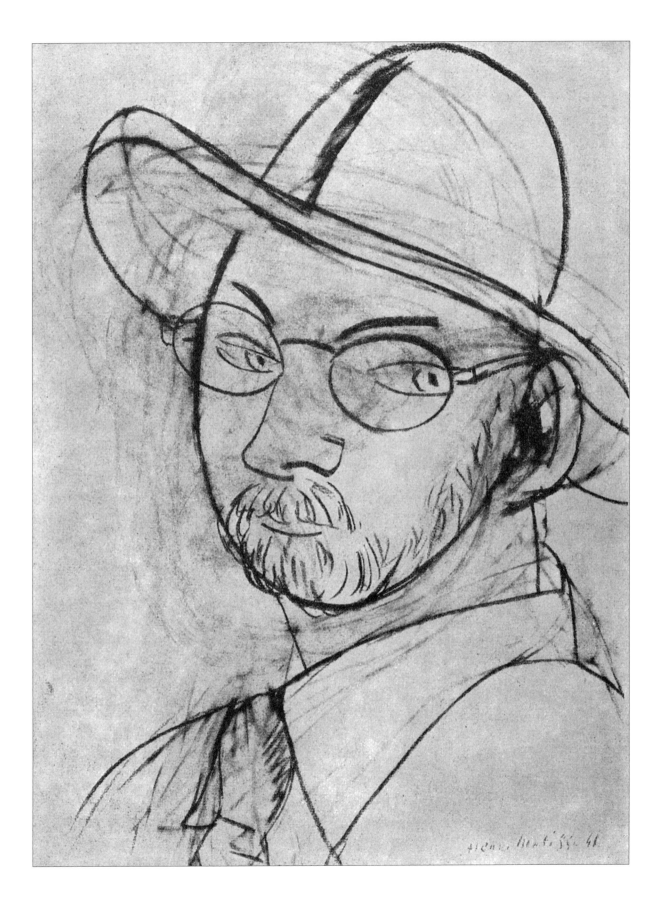

39 / HENRI MATISSE (1869–1954)
Self-portrait with Straw Hat, 1941. Sanguine chalk on paper. 48 x 37.5 cm.

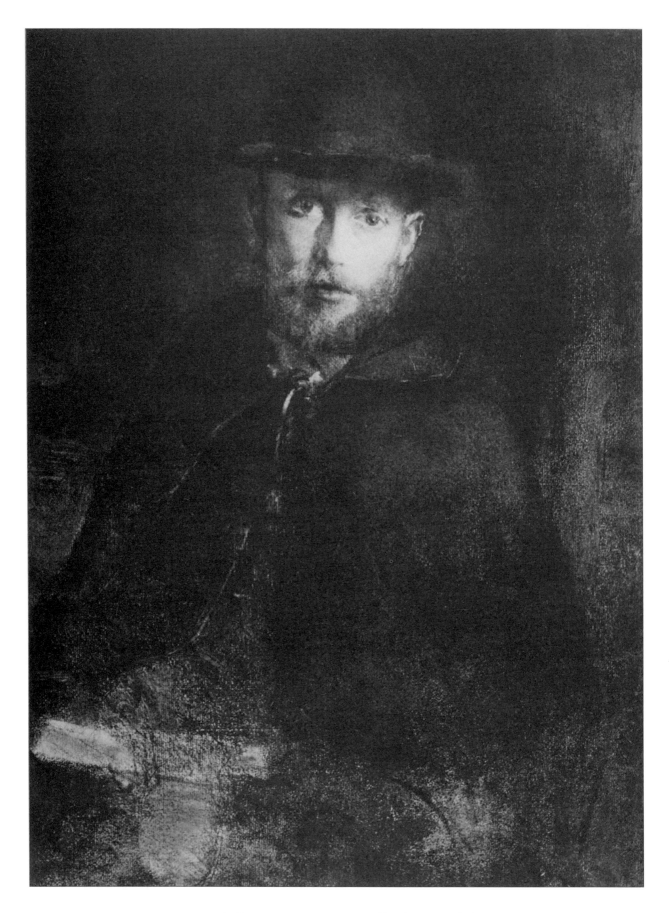

40 / GEORGES ROUAULT (1871-1958)
Self-portrait, 1895. Charcoal and crayon with pastel. 73.1 x 54 cm.

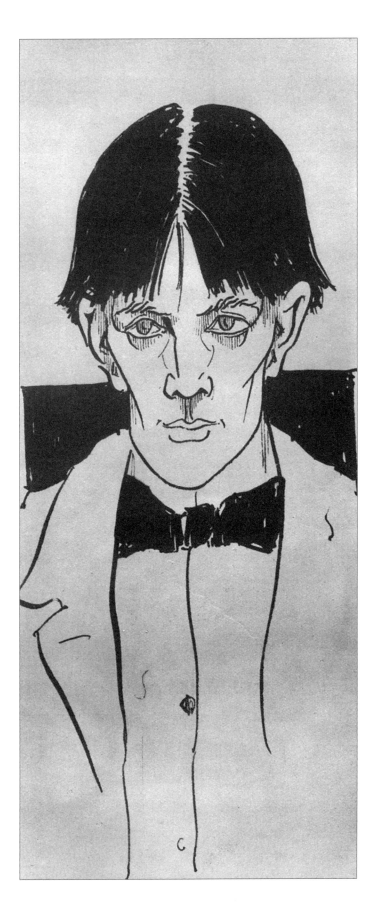

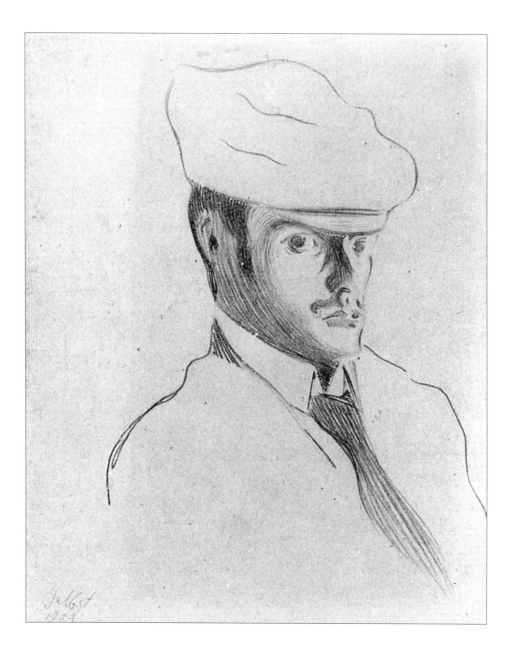

42 / Paul Klee (1879-1940)
Self-portrait with a White Hat, c.1899. Pencil on paper. 13.7 x 12.9 cm.

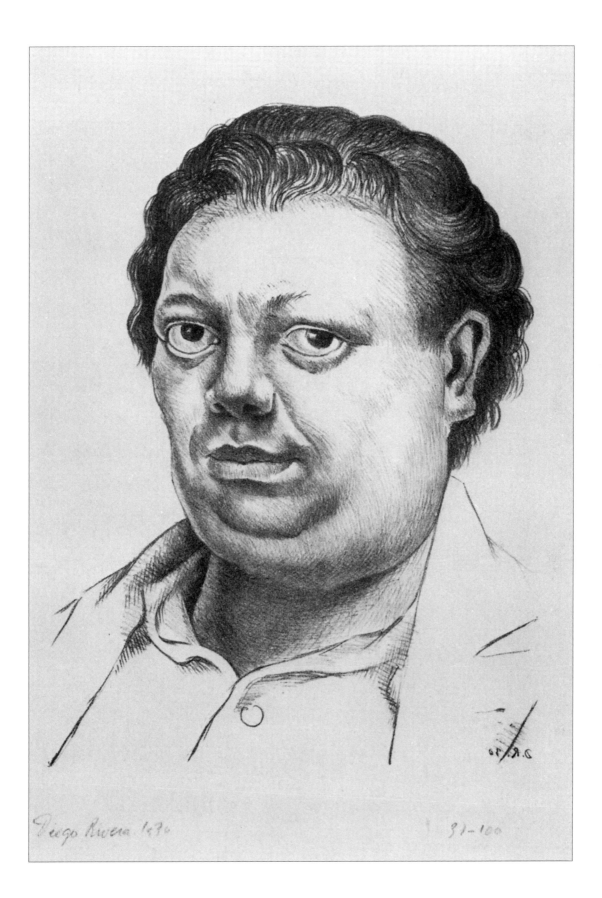

43 / DIEGO RIVERA (1886-1957)
Self-portrait, 1930. Lithograph. 40.2 x 28.3 cm.

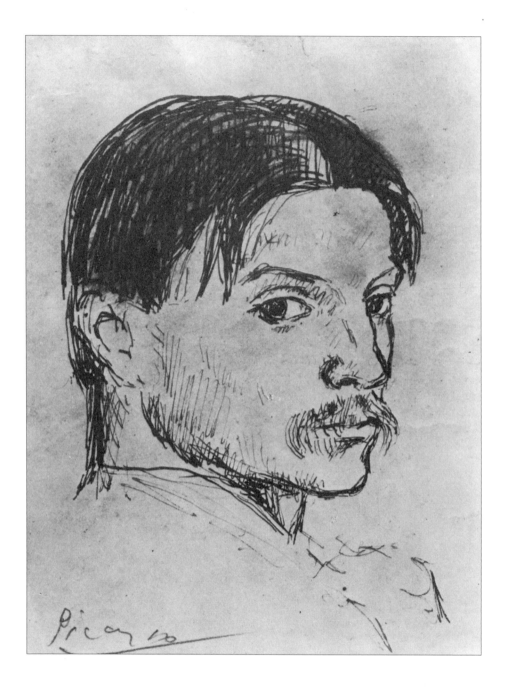

44 / PABLO PICASSO (1881-1973)
Self-portrait, 1912. Pen and ink.